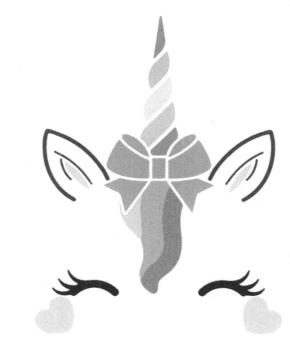

This Book Belongs To

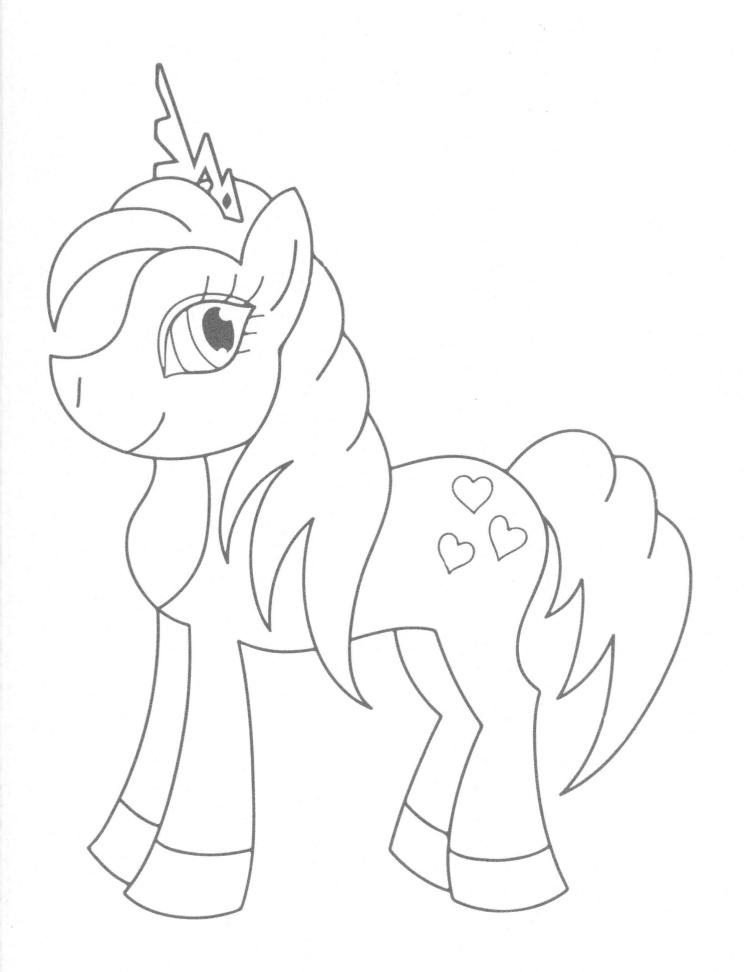

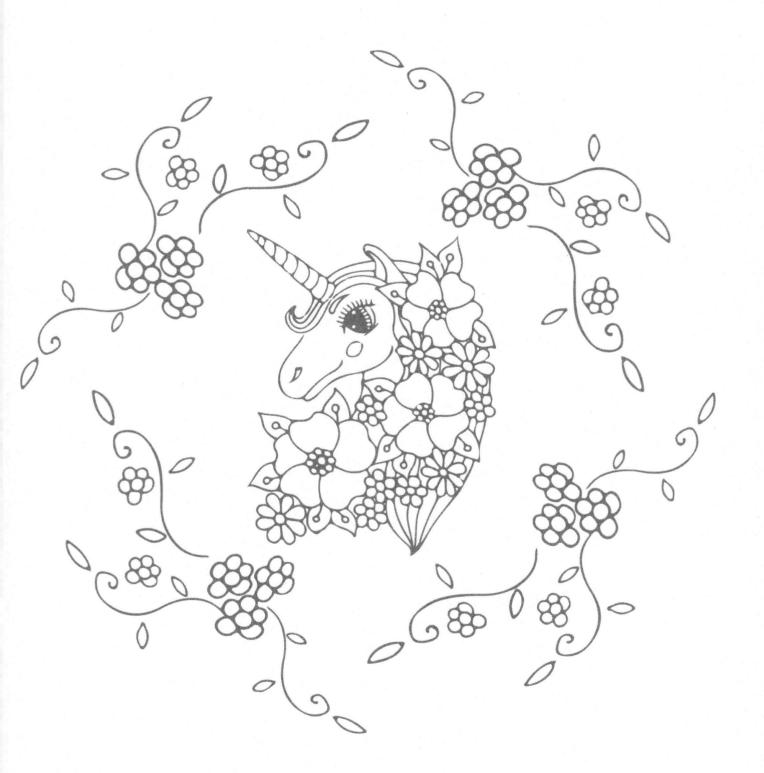

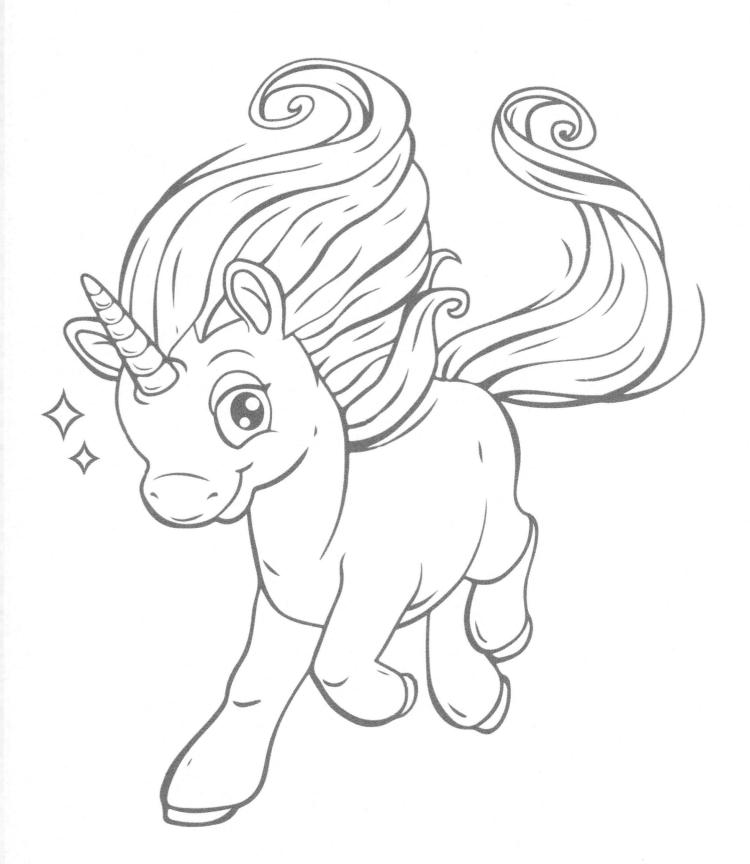

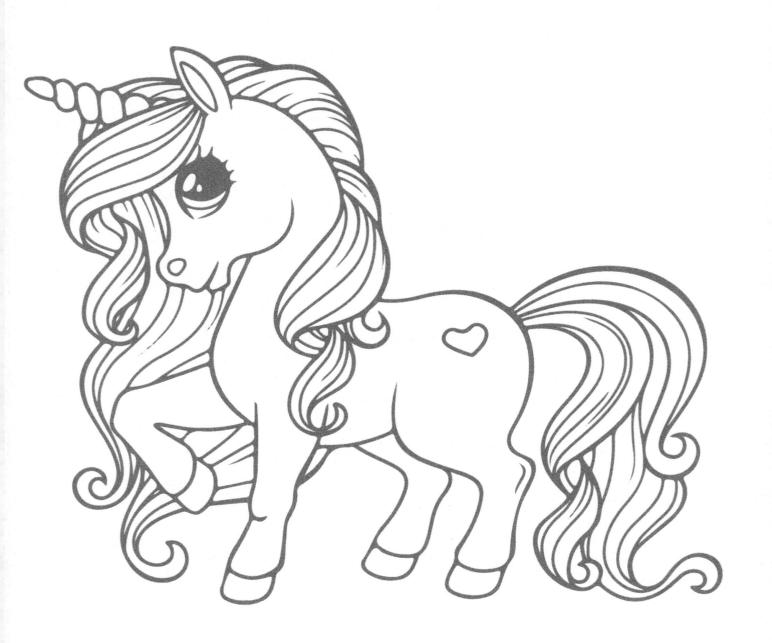

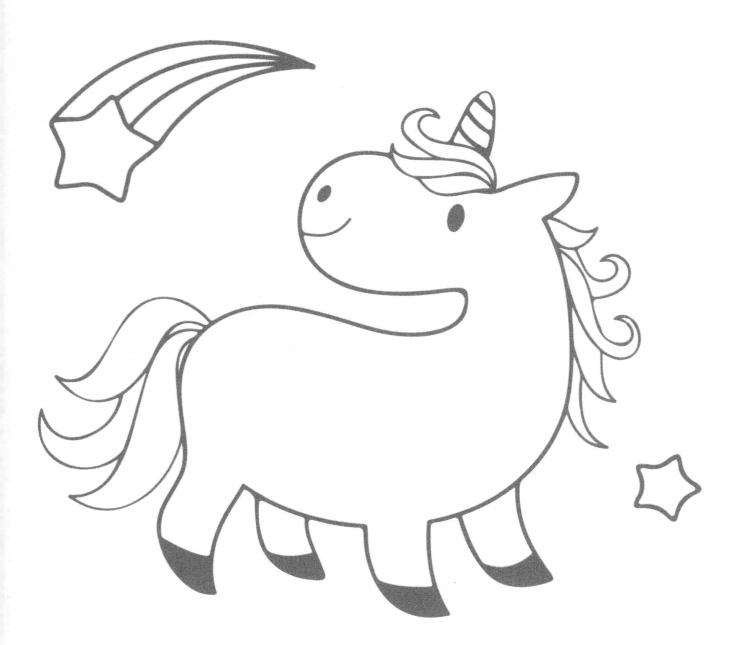

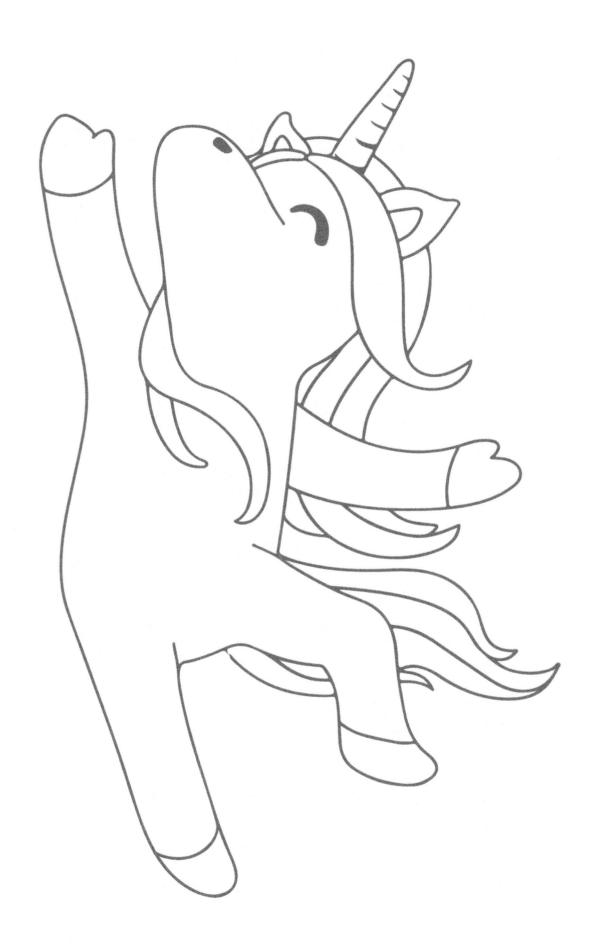

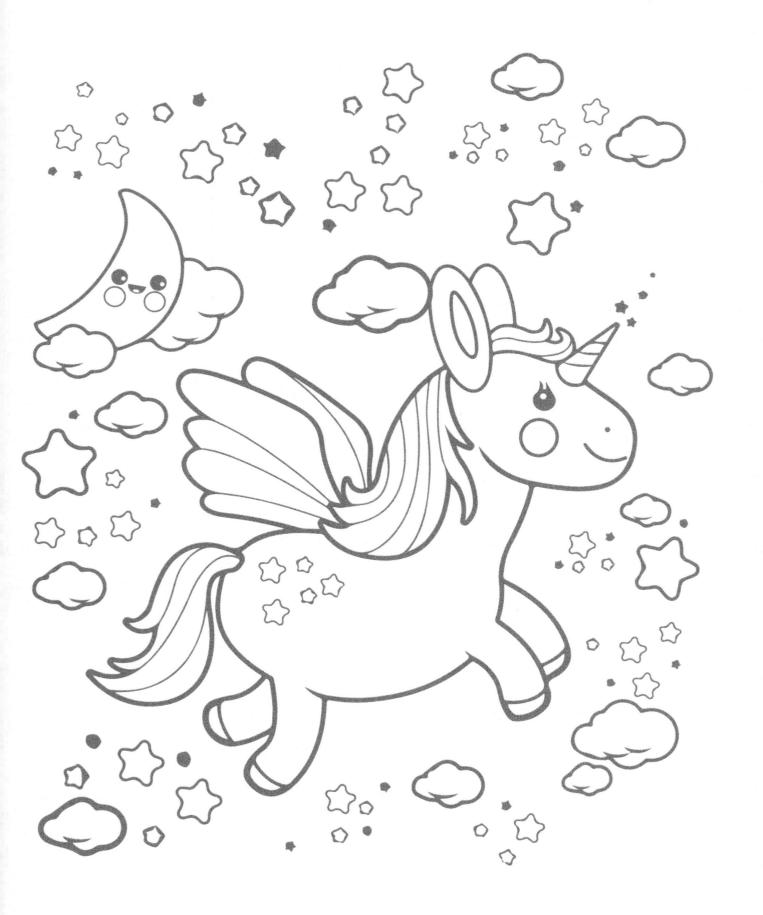

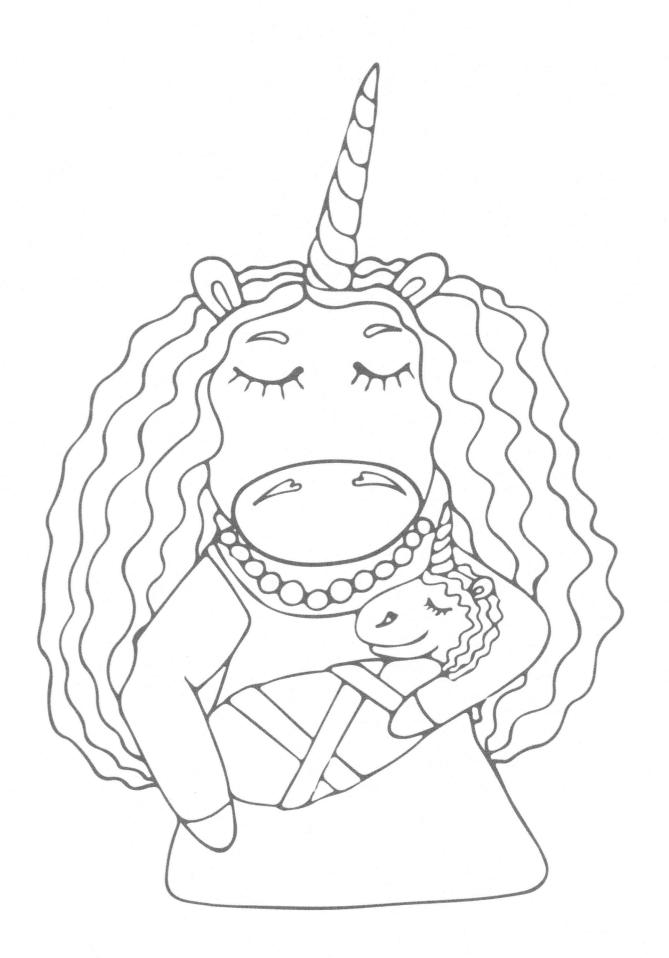

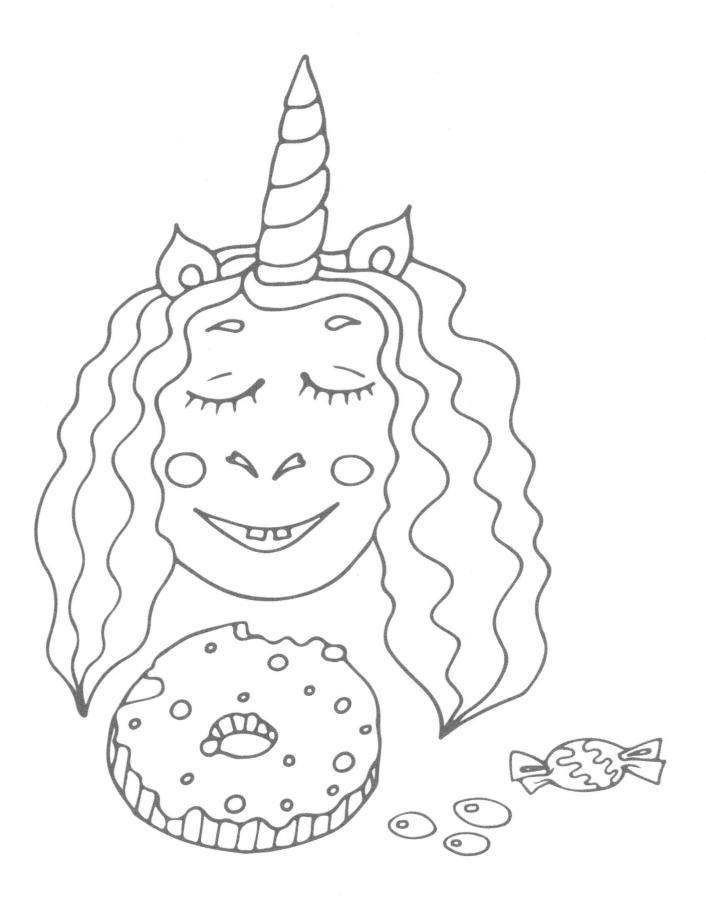

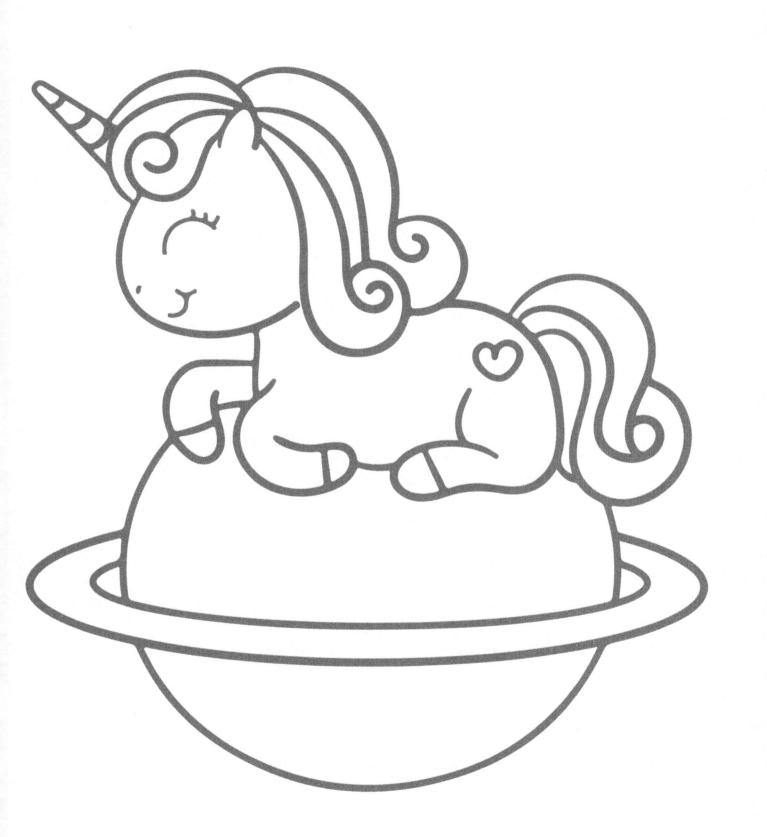

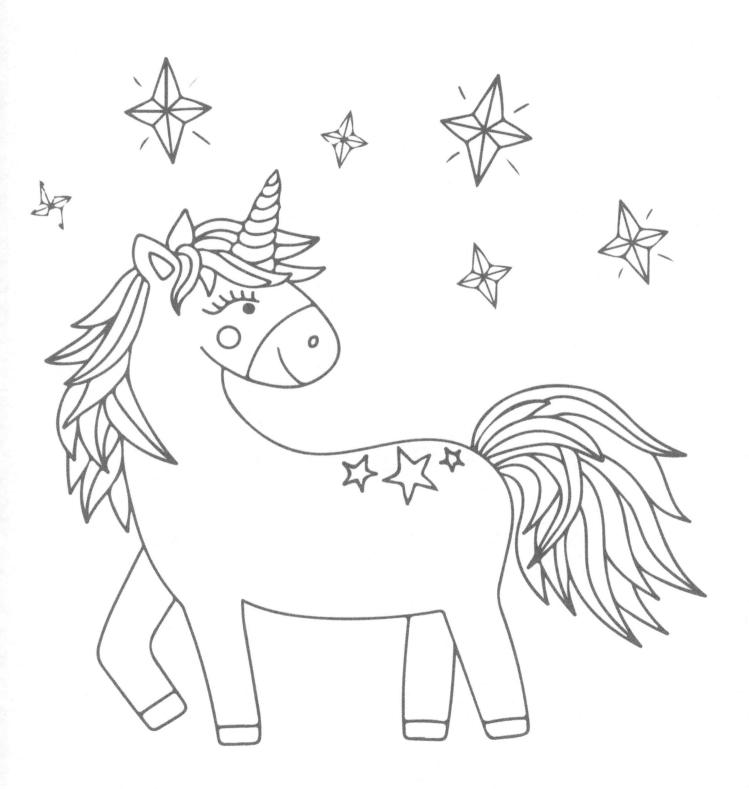

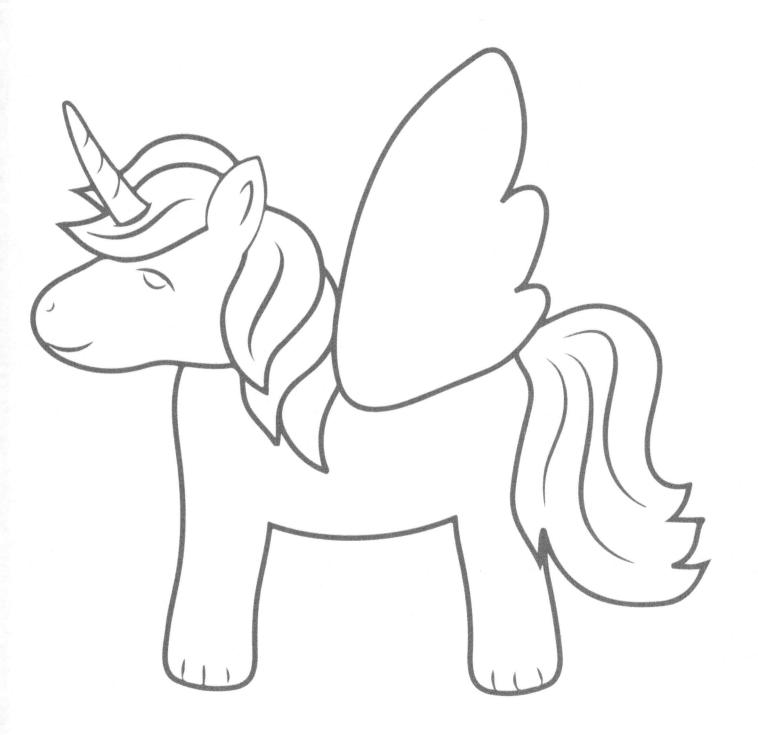

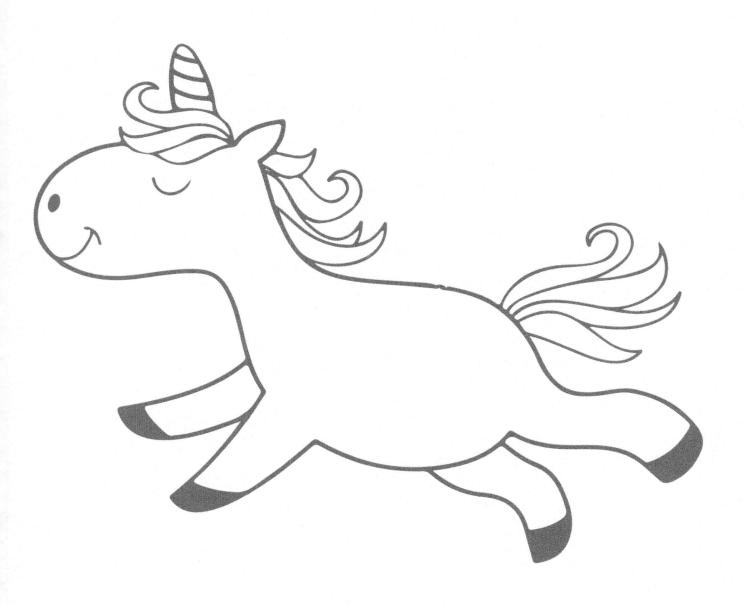

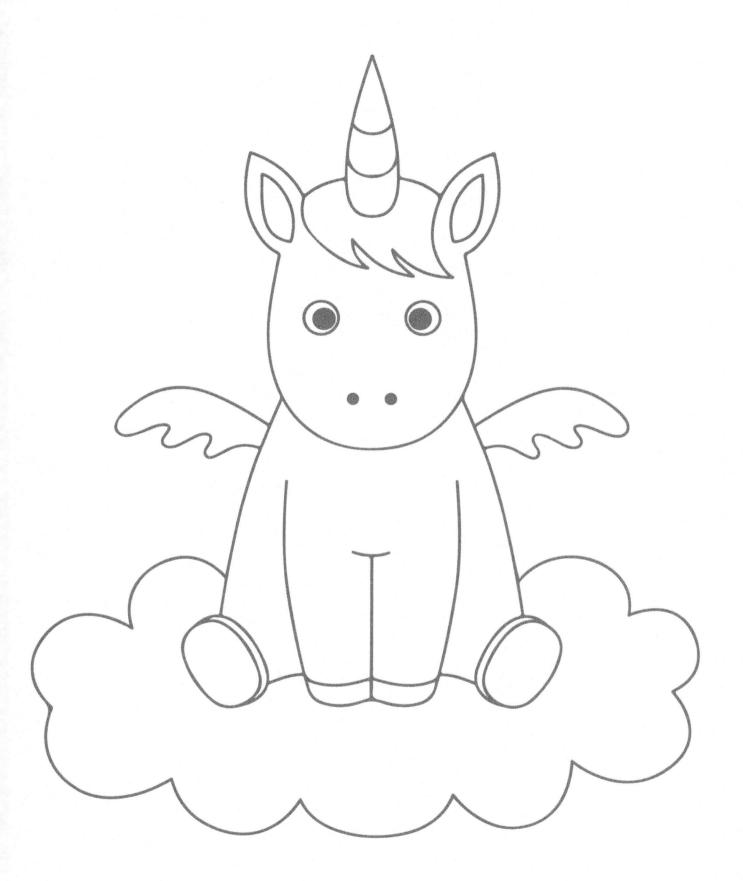

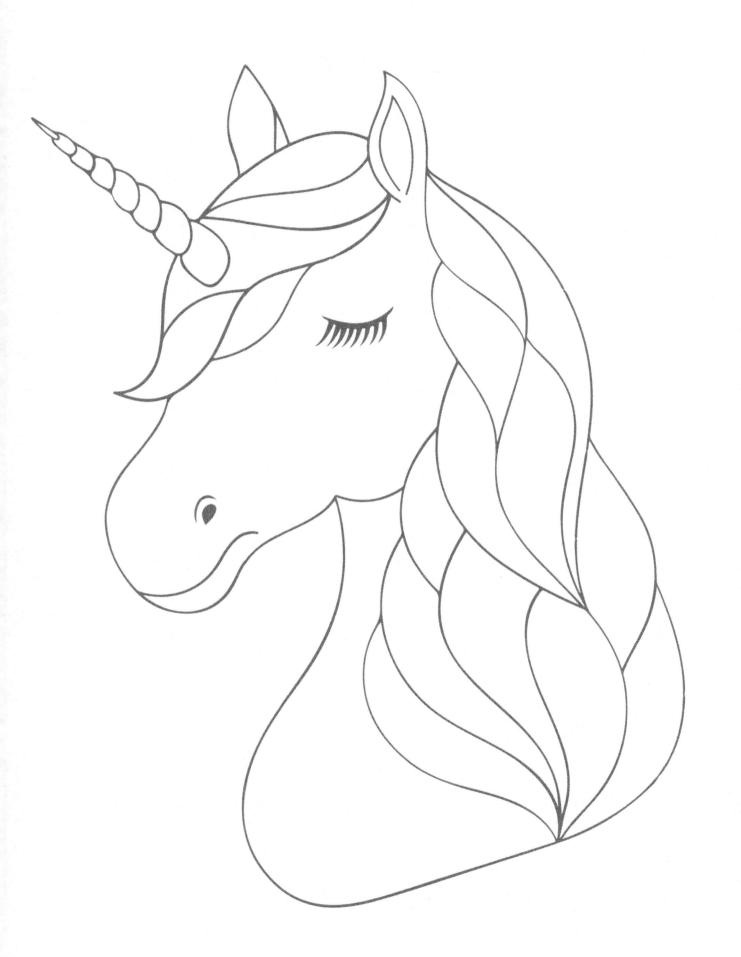

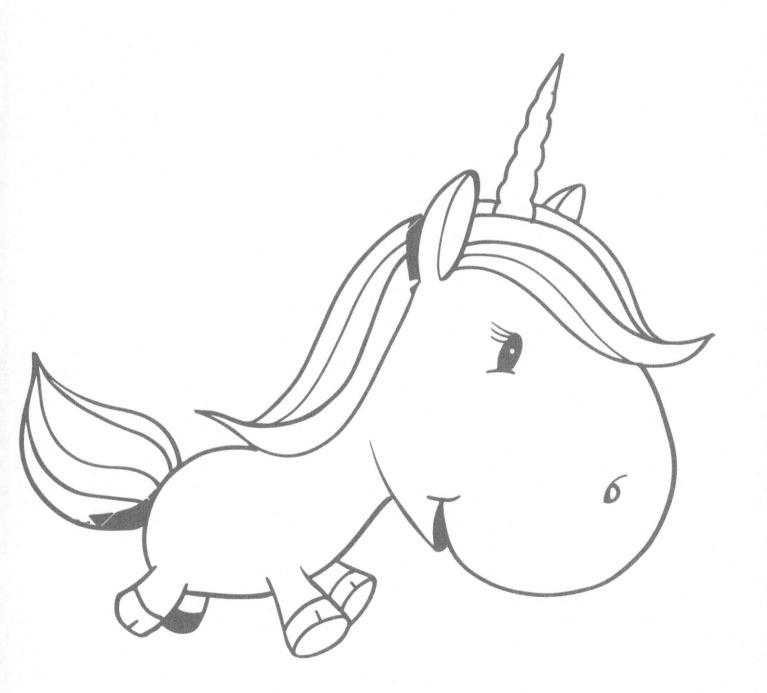

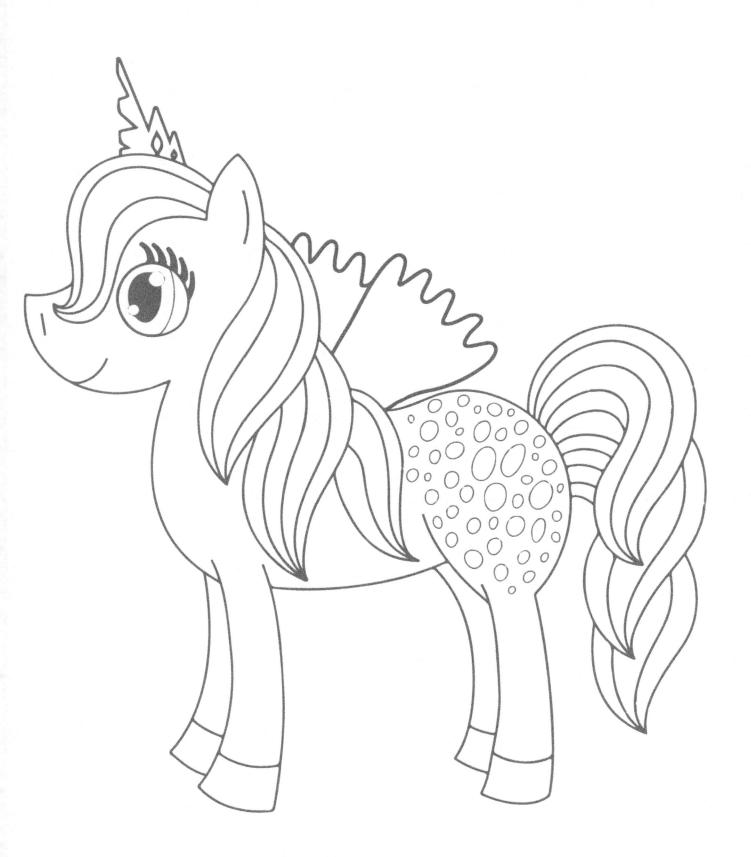

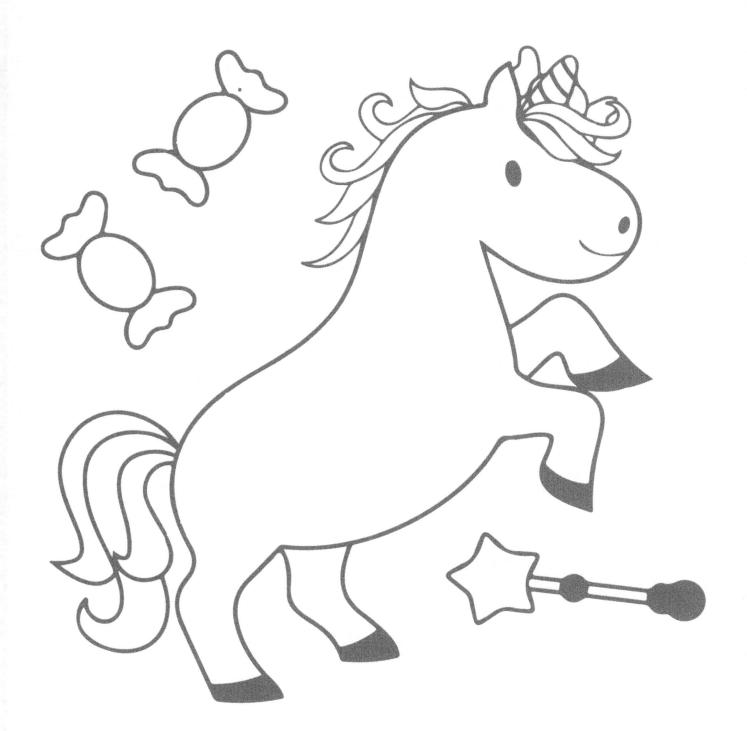

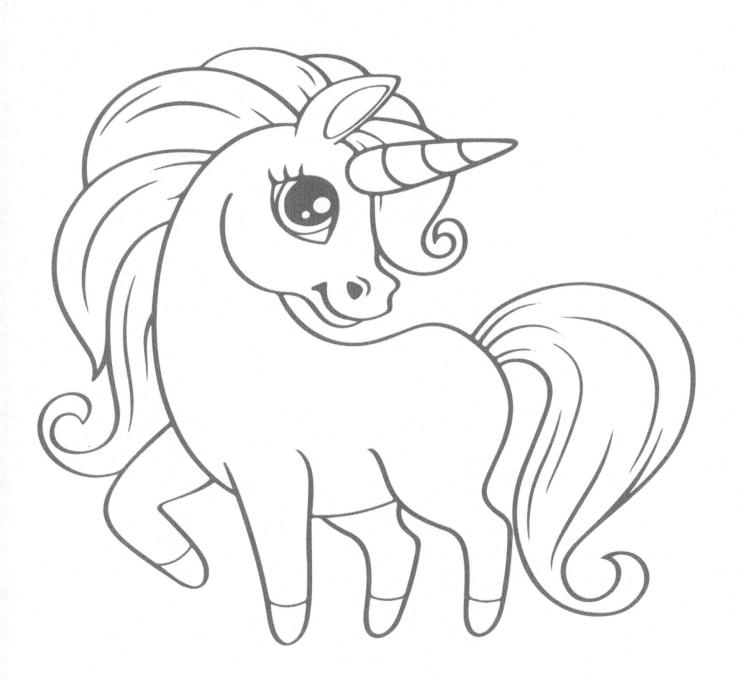

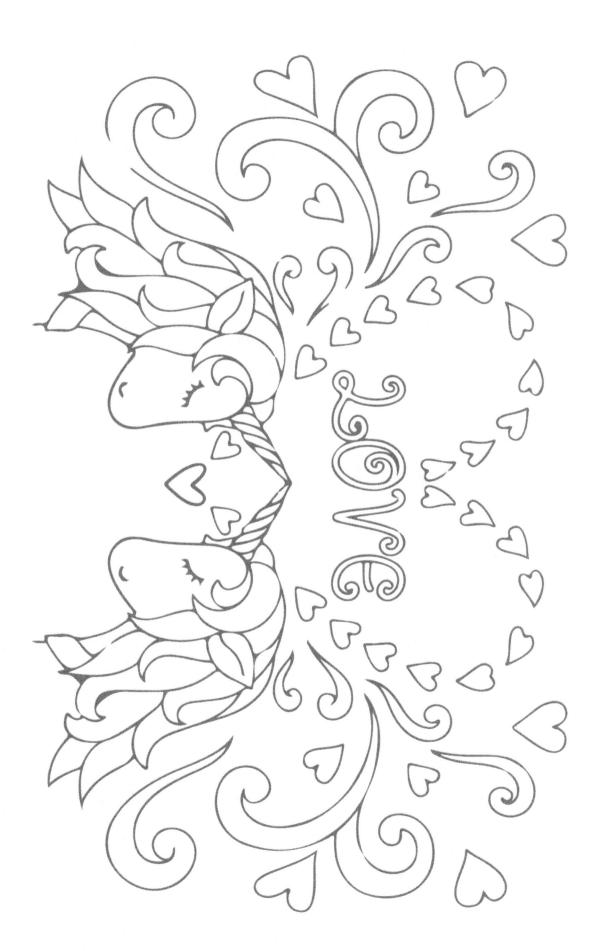

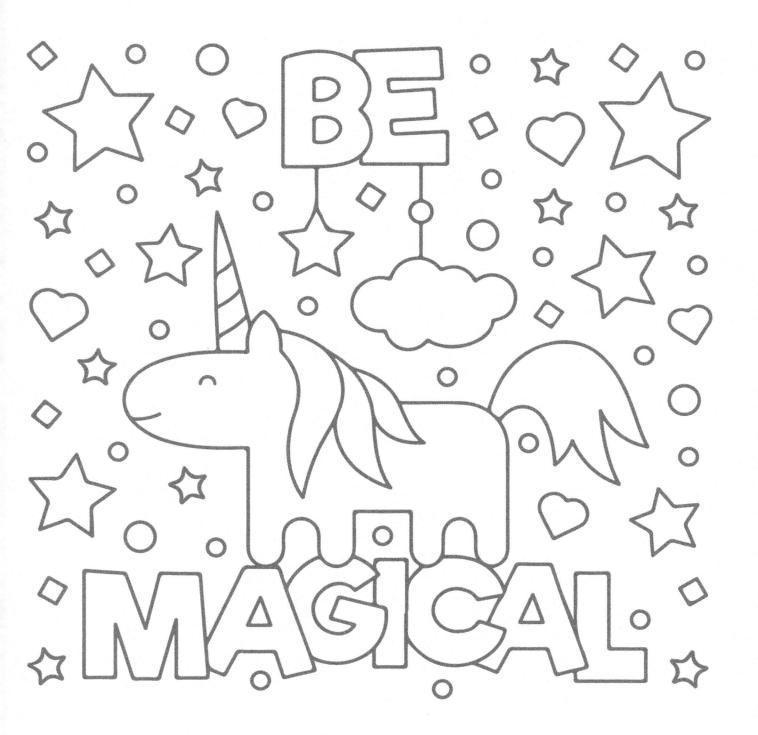

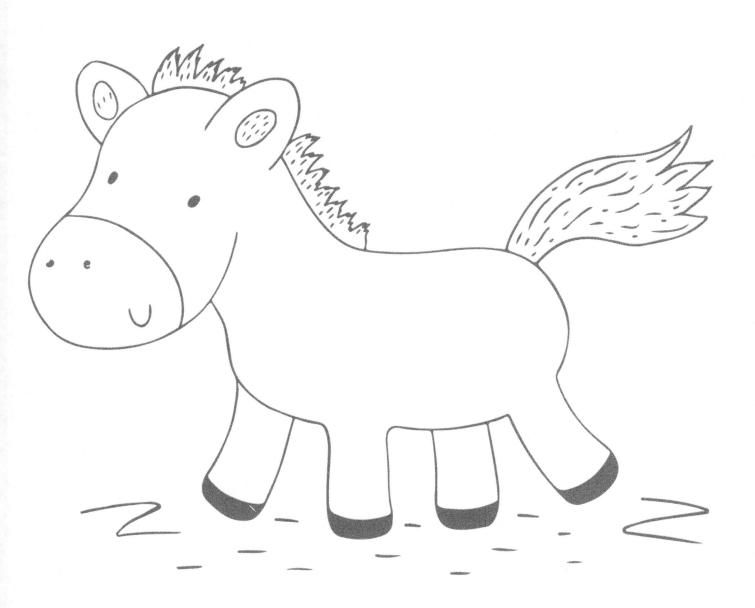

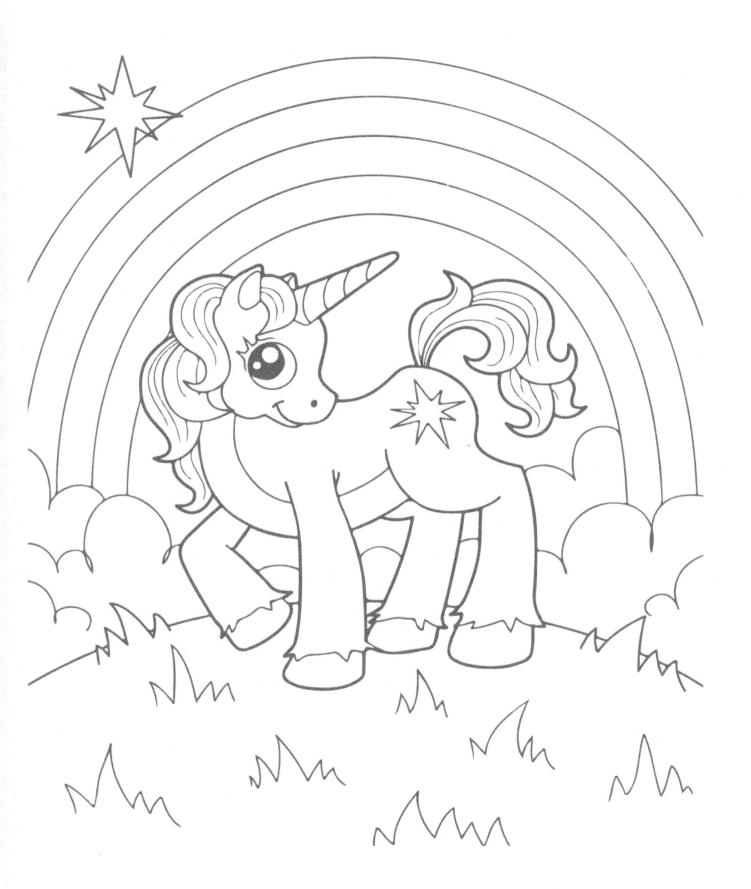

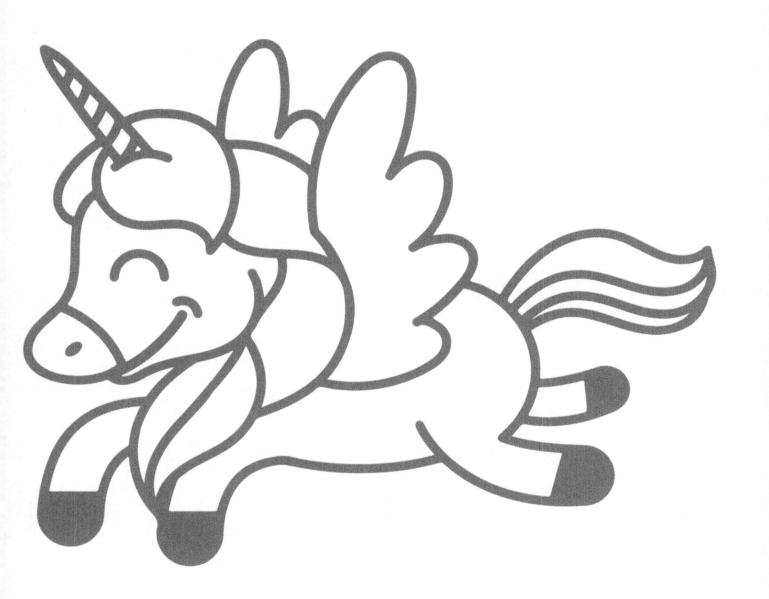

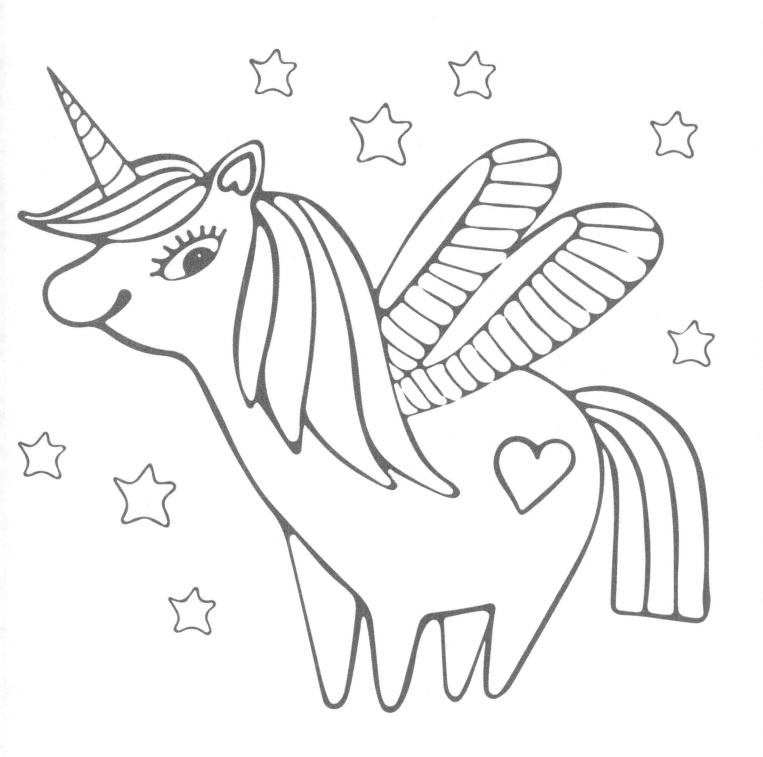

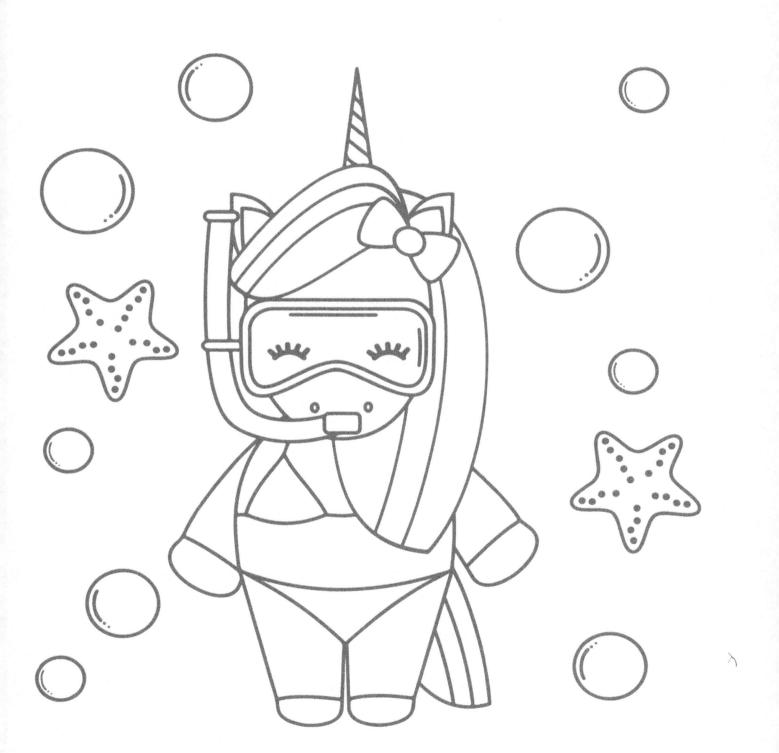

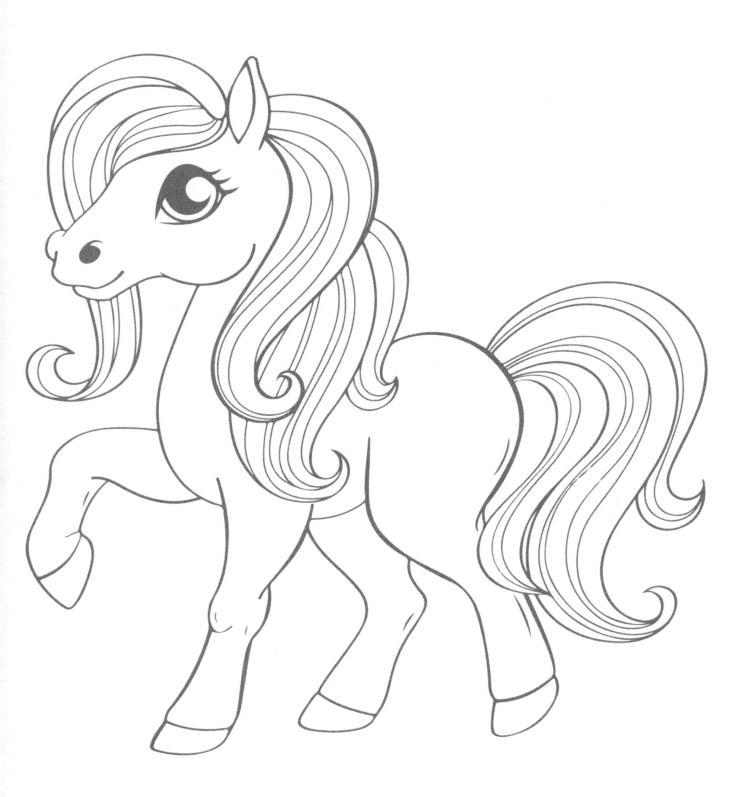

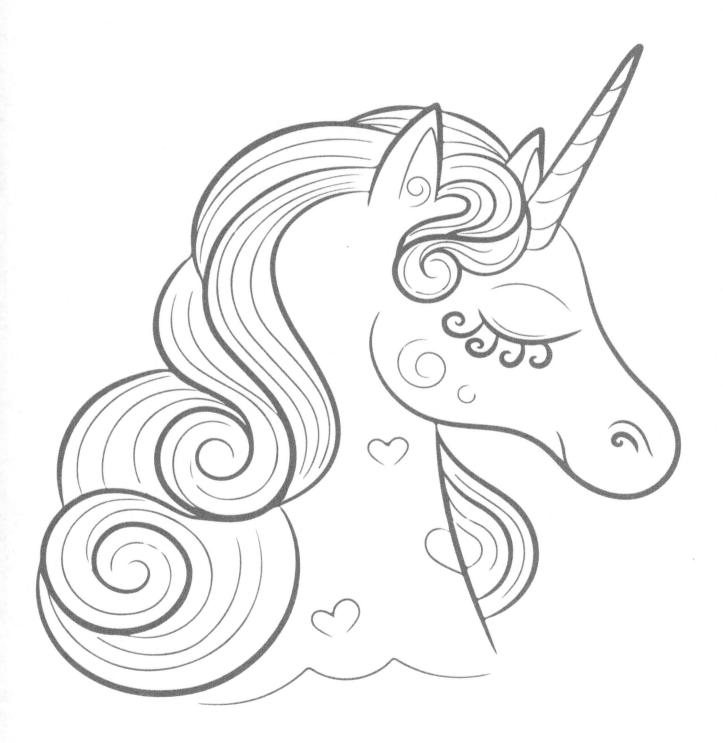

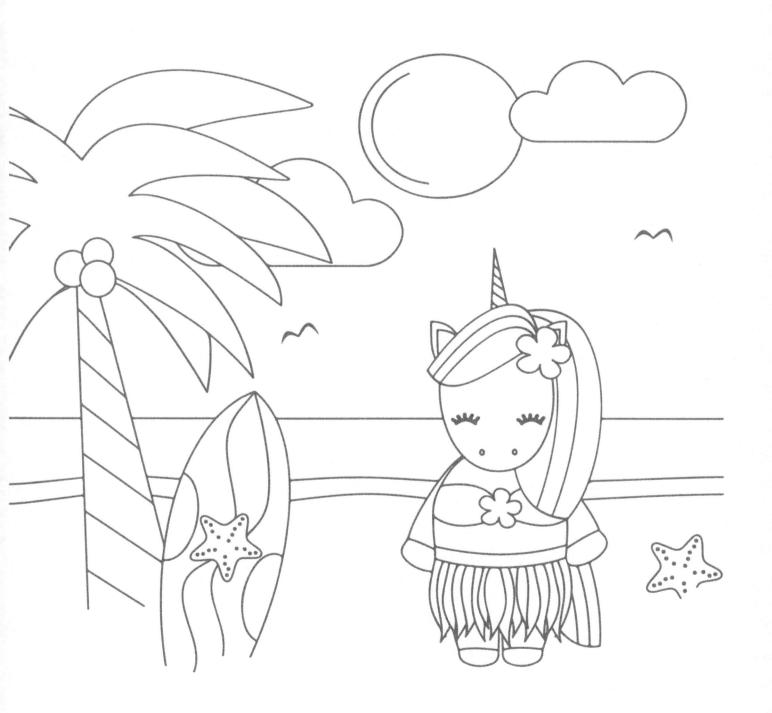

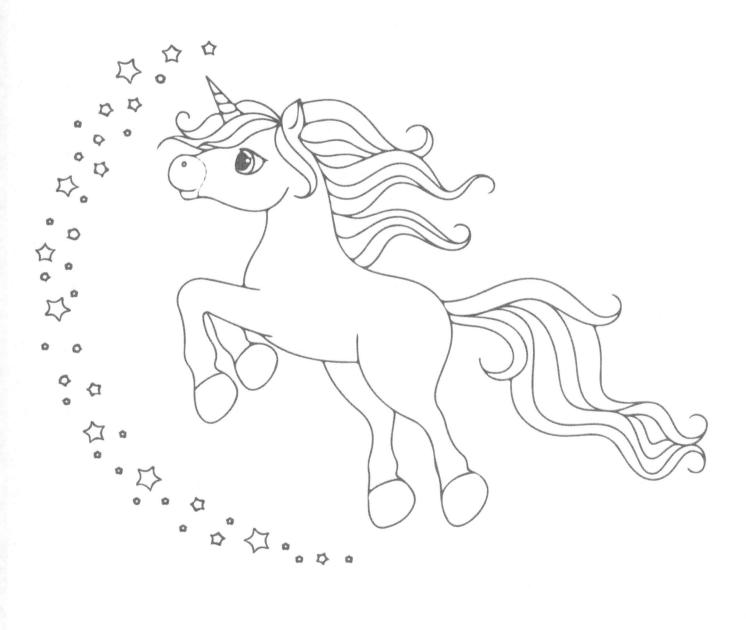

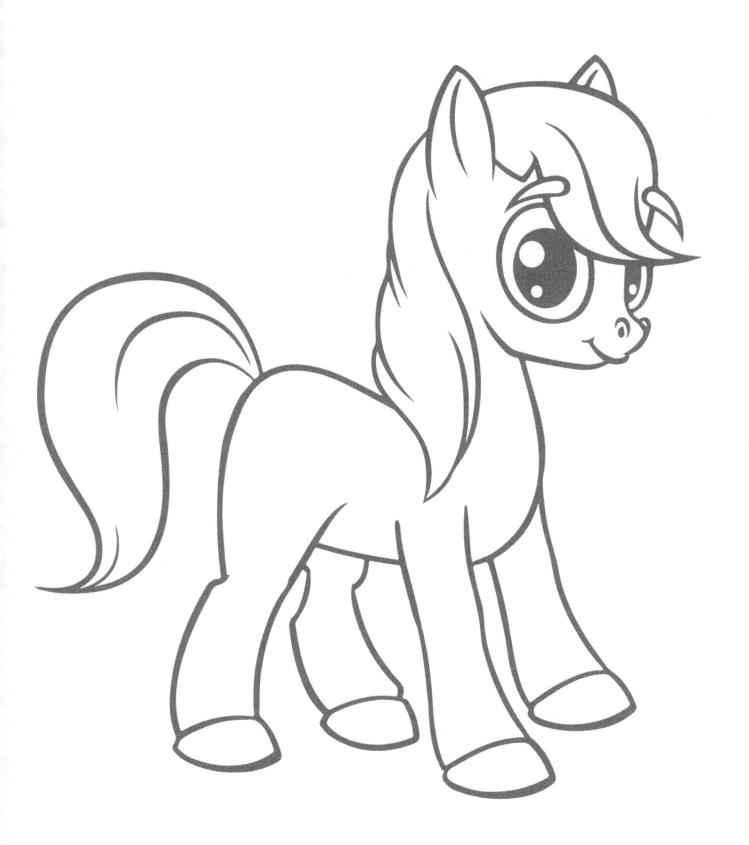

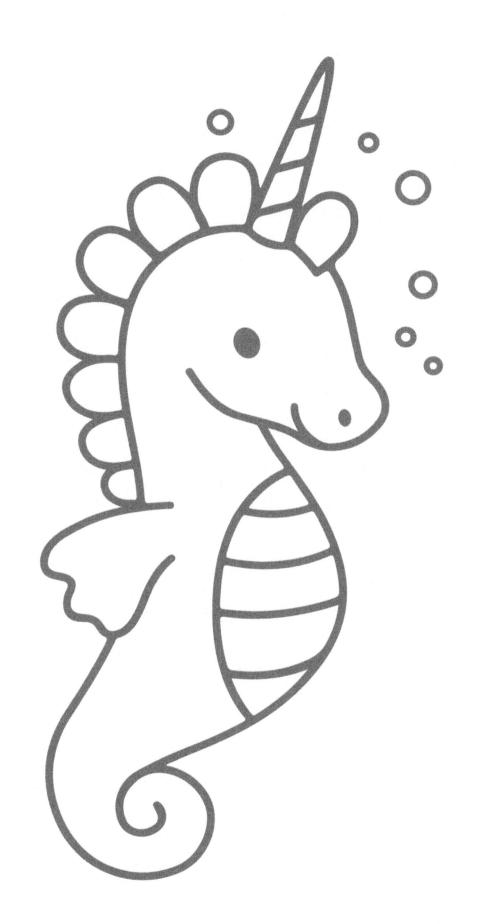

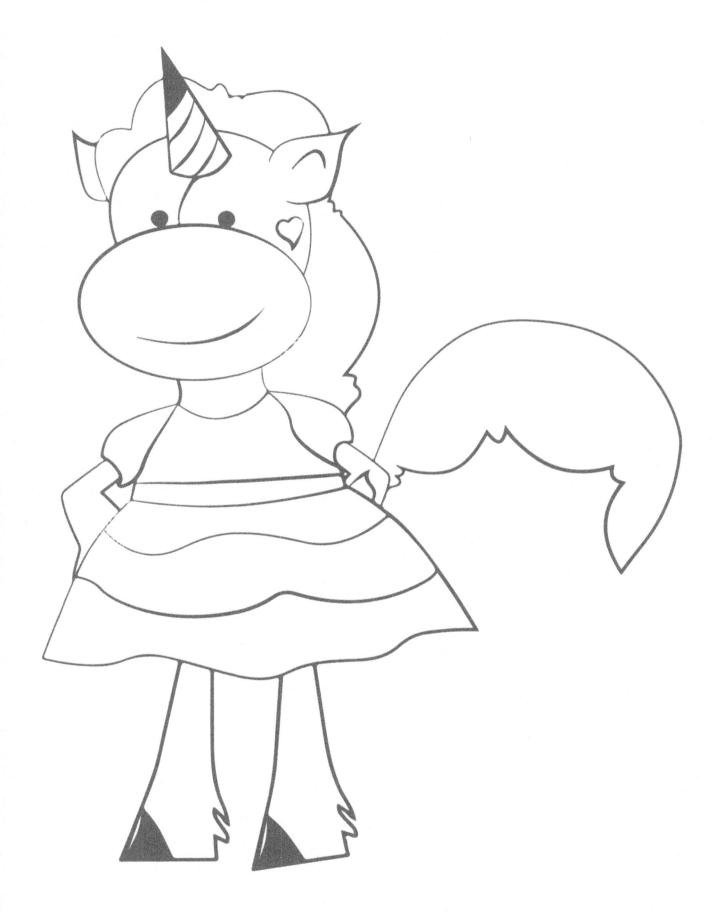

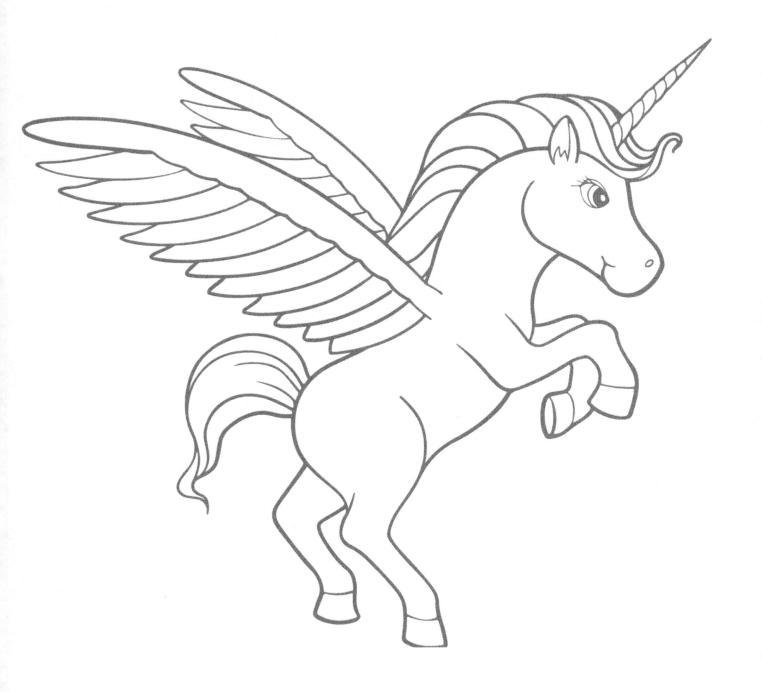

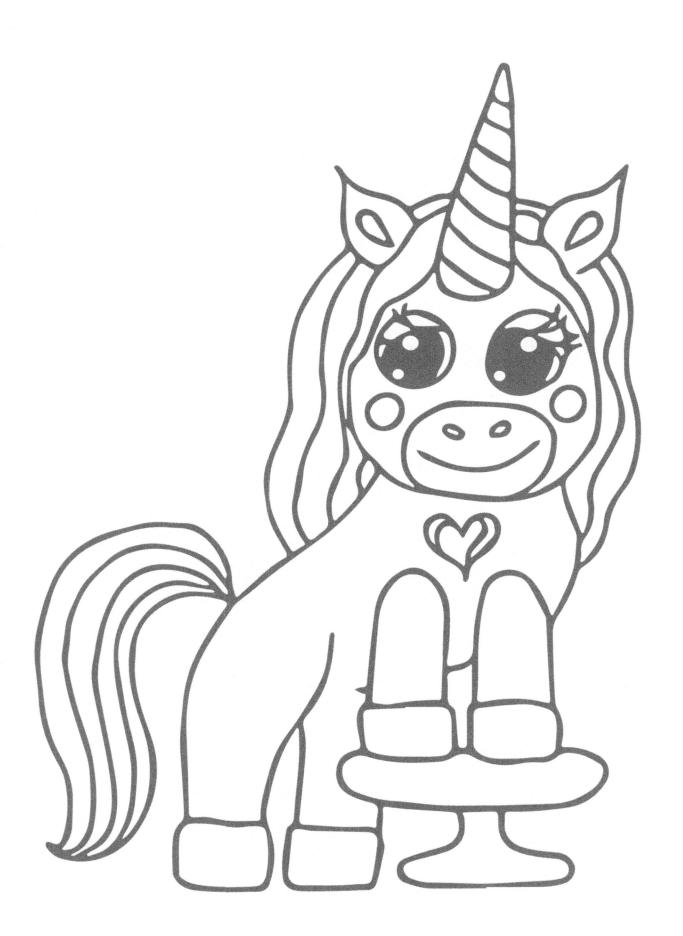

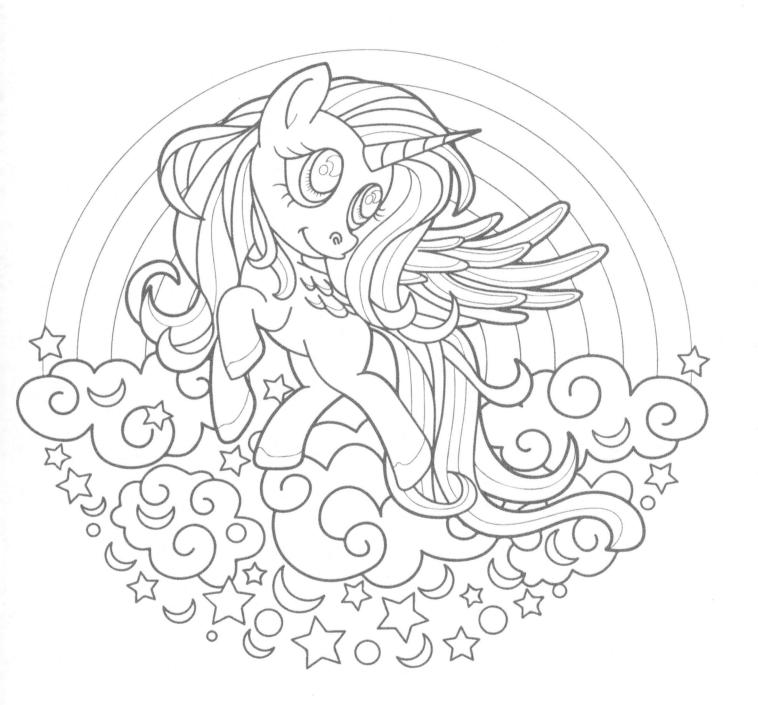

Made in the USA Coppell, TX 21 June 2022